THE LIFE AND WORKS OF
HIERONYMUS
BOSCH
Trewin Copplestone

A Compilation of Works from the

BRIDGEMAN ART LIBRARY

The Life and Works of Hieronymus Bosch

This edition printed for:
Shooting Star Press Inc.
230 Fifth Avenue – Suite 1212
New York, NY 10001

Shooting Star Press books are available at special discounts for bulk purchases for sales promotions, premiums, fund-raising, or educational use. Special edition or book excerpts can also be created to specification. For details contact: Special Sales Director, Shooting Star Press Inc., 230 Fifth Avenue, Suite 1212, New York, NY 10001

© 1995 Parragon Book Service Limited

ISBN 1-57335-032-X

Printed in Italy

Editors:	Barbara Horn, Alexa Stace, Alison Stace, Tucker Slingsby Ltd and Jennifer Warner
Designers:	Robert Mathias • Pedro Prá-Lopez, Kingfisher Design Services
Typesetting/DTP:	Frances Prá-Lopez, Kingfisher Design Services
Picture Research:	Kathy Lockley

The publishers would like to thank Joanna Hartley at the Bridgeman Art Library for her invaluable help.

Hieronymus Bosch 1450-1516

Although possessing one of the most extraordinary, creative and unconventional imaginations in the whole history of Western art, the painter known as Hieronymus Bosch appears to have lived a quiet and disciplined life in the small prosperous town in which he was born. His paintings are full of vivid images of figures enduring the most hideous inventive tortures ever depicted in painting, but are deeply religious in feeling and full of an arcane, still not fully understood symbolism.

It is not surprising that such a painter should be of great interest to scholars, art historians and psychologists. However, unlike many artists, he left no writings and did not name or date any of his works, so it is only by internal stylistic and historical evidence that any chronological order can be attempted, and then only tentatively.

There is no record of his birth, but it seems that he was born in about 1450 in the northern Netherlands town of s'Hertogenbosch in the Duchy of Brabant, part of the realm of the Dukes of Burgundy and not far from the Belgian border. He came from a family of painters; his grandfather, father, three uncles and a brother were also all professional painters, whose family name, van Aken, suggests that they were originally from Aachen. Possibly to distinguish himself from the rest of his family, as a painter he adopted the Latinized version of his first name, Jerome, and a shortened form of his hometown and became Hieronymus Bosch. He married into a wealthy family in about 1480 and subsequently lived in the market square as a prosperous city

burgher as well as a painter. He appears to have been deeply religious himself and became a member of the highly respected Brotherhood of Our Lady, which venerated the Virgin Mary. Although he was widely popular and admired during his lifetime, there are no authenticated portraits of him nor any stories concerning his life and activities in s'Hertogenbosch.

Many attempts have been made to construct the character of this mysterious figure. One recent scholar, through the analysis of his paintings, has concluded that Bosch was a moralist with a contempt for the lower classes and no sympathy for the poor, who used a biting and bitter satire in his depiction of beggars, monks and nuns, soldiers, peasants, whores, pilgrims and vagrants. Bosch, he claims, rarely attacked burghers like himself, but sometimes poured scorn on the higher levels of Church and state while his greatest antipathy was towards lust, licence and self-indulgences such as gluttony. He also believes that Bosch liked to dwell on erotic scenes and on the infliction of pain. Other scholars and art historian, however, have felt that Bosch had much sympathy for the plight of his fellow humans in a harsh world.

The times in which Bosch lived were remarkably violent and vicious. During the Late Middle Ages in northern Europe the power and authority of the Church were being attacked both from without and within. The growth of new cities as a result of a vigorous commercial energy and the rise of the national states gave a different focus to life, while the beginnings of scientific research and the questioning of Church teaching led to demands for reform. It was the time of Erasmus's *The Praise of Folly*, of Luther's battle with the Church over the sale of indulgences, and only the beginning of the influence in the north of the Renaissance in Italy. It is interesting to note that although Bosch was an almost exact contemporary of Leonardo da Vinci (1452-1519), one of the great figures of Renaissance Italy, a close contemporary of others, such as Michelangelo (1475-1564), Titian

(1477-1576) and Raphael (1483-1520), his own work shows more elements of the medieval mind than of any Renaissance consciousness.

Perhaps most significant in its longer term effect on the whole of society, including the Church, was the invention of printing with movable type only a few years before Bosch was born. By the time he reached adulthood printing was a widespread factor in the expansion of learning as well as diminishing the influence of the priesthood. It also, indirectly, had an effect on the subsequent reputation and influence of Bosch's work after his death. The impact of literacy to some degree removed the need to 'read' works of art in the way that had been universal in the Middle Ages, and the severe demands of the complicated symbolism that infused all his paintings were no longer attractive. During the 400 years from the death of the painter until the beginning of this century his work was little looked at or considered. It is only since Freud and other psychoanalysts began to reveal the inner workings of the human mind, the outpourings of the unconscious, that Bosch's unique imagination has been explored and his paintings examined with wondering enthusiasm.

In the absence of any documentation it has proved impossible to establish with any certainty the chronology of Bosch's work. Scholars are not agreed except in the establishment of three general periods: early, middle and late; the paintings in this book follow that pattern.

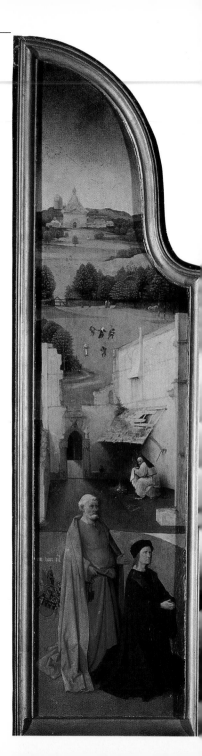

▷ **Epiphany**

Oil on panel

THE *EPIPHANY*, also known as the *Adoration of the Magi*, is an early work dating before 1480. The painting depicts the presentation of the child Christ by Mary to the three wise men from the East, who bring gold, frankincense and myrrh to the stable in which he was born. Joseph is watching, and two other figures and animals may be seen in the stable. The highly personal inventive imagination of Bosch's later work is not evident here, but this loving treatment of the landscape of the Lowlands is seen in many of his later works.

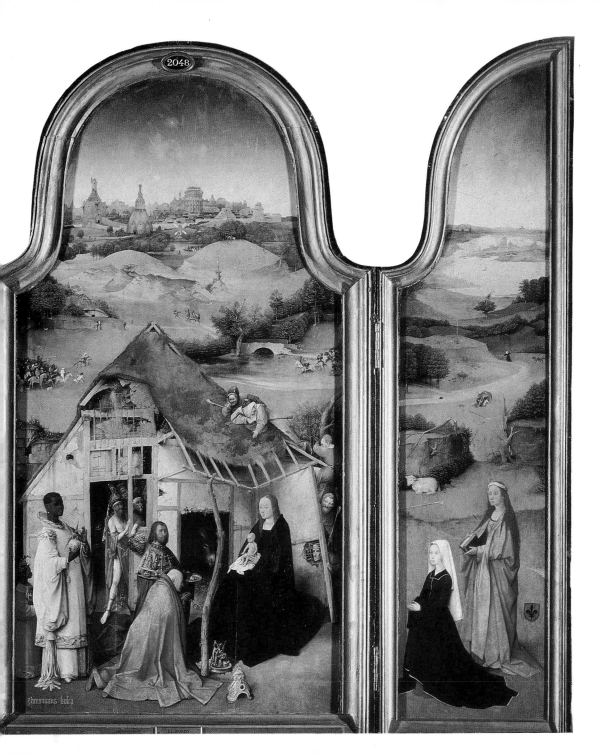

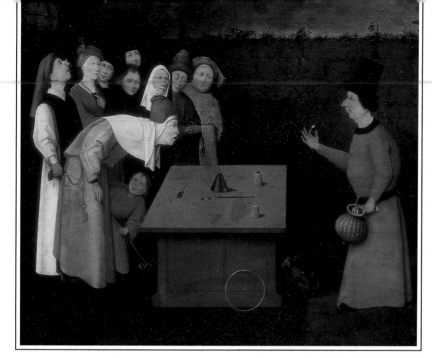

△ The Conjuror

Oil on panel

THIS IS AN UNUSUAL WORK for Bosch, whose subjects are almost all religious, and dates from his early period before 1480. Although this picture is believed to be a careful and accurate copy of a lost original, the quality of the drawing, particularly of the conjuror and his bending-forward victim, does not appear to be of the standard that we encounter in even the early Bosch paintings. There are, however, one or two suggestions of Bosch: note the owl looking from the basket the conjuror is holding and the small dog or monkey in jester costume. The story is not the straightforward one that it appears. The conjuror is apparently materializing a frog from the mouth of his subject; evidently a second one, since one already sits on the table. The onlookers show a variety of emotions from disbelief and lack of interest to the fascination the small child evinces. But the man standing behind the victim and gazing to the heavens is at the same time removing the purse – he is obviously the conjuror's confederate.

▷ The Marriage Feast at Cana

Oil in panel

PAINTED BY BOSCH towards the end of his early period, this is not a traditional treatment of the subject. The marriage at Cana is the story of Christ's first miracle – turning water into wine. The bride and bridegroom are central while the figure of Christ is placed on the right in front of the brocaded cloth of honour, customarily the bride's place. Christ's hand is raised in blessing. Although not mentioned in the Bible, the groom has been identified by Bosch as St John. It has also been contended that the bride is Mary Magdalene. There was a tradition that at the end of the feast Christ called to the groom to leave his bride and follow him. The fact that St John is known as Christ's best loved disciple lays a special emphasis on the interpretation. The symbolism is of a spiritual chastity more elevated and pure than the carnal union of marriage. The incidentals also attract great interest: the water jug filling wine jars; the drunken bagpiper suggesting a tavern, a licentious setting; a swan (an emblem of Venus) spitting fire, suggesting the opposite of chastity. Each part of the painting carries such messages, often hidden to us but recognizable to Bosch's contemporaries.

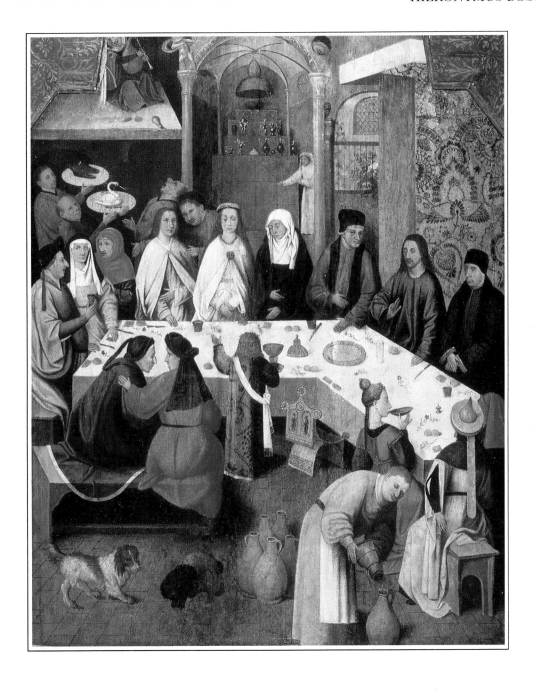

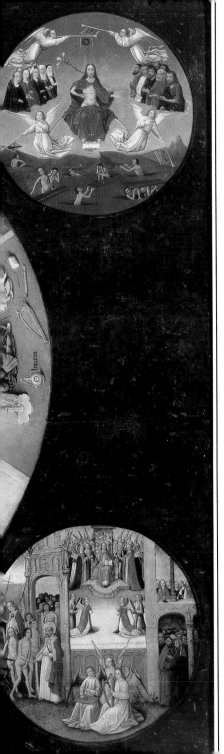

◁ Tabletop of the Seven Deadly Sins and the Four Last Things

Oil on panel

THE HUMAN CONDITION and humanity's ultimate fate form the overall subject of this series of images. The central feature, formed of four concentric rings, symbolizes the eye of God, the pupil of which shows Christ rising from the grave displaying the wounds of his crucifixion. The second ring carries the message inscription *Cave Cave Deus vivit* (Beware Beware God sees). The third ring is formed of sun-like rays, while the fourth depicts the seven deadly sins in separate panels. Banderols at top and bottom carry Latin warning inscriptions. Of the four circular corner images – the Four Last Things – the one depicting hell is the most revealing of Bosch's development and the deeply disturbing creatures that he increasingly uses to identify the torments of the human soul in its journey to almost inevitable damnation. Internal evidence of, for instance, dress indicates that the painting dates from around 1490, early in Bosch's middle period. Most of the scenes are not of the highest quality, but the message is clear and unequivocal.

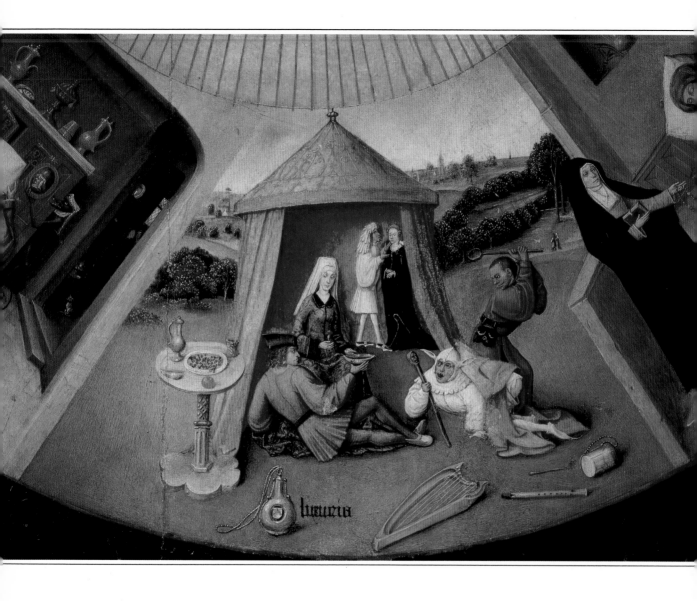

Detail

◁ **Lust** *(detail from Tabletop)*

Oil on panel

The two pairs of lovers dallying in a richly brocaded tent, engaged in a formal game of love as a prelude to the full expression of their passion, are located in an idyllic landscape, with food and wine as proper accompaniments. The deadly sin of lust, the original sin for which man was ultimately damned, carries with it the added incitement of pleasure and pain, which the jester and clown suggest. Other symbols are the lyre, associated with the music of love; and the wine, which is free flowing, loosening the restraints of the lovers. Little in Bosch's work is accidental and it should be noted that the wall bounding the right side of the scene is cut away to allow the reminder of the presence of the nun and the holy life.

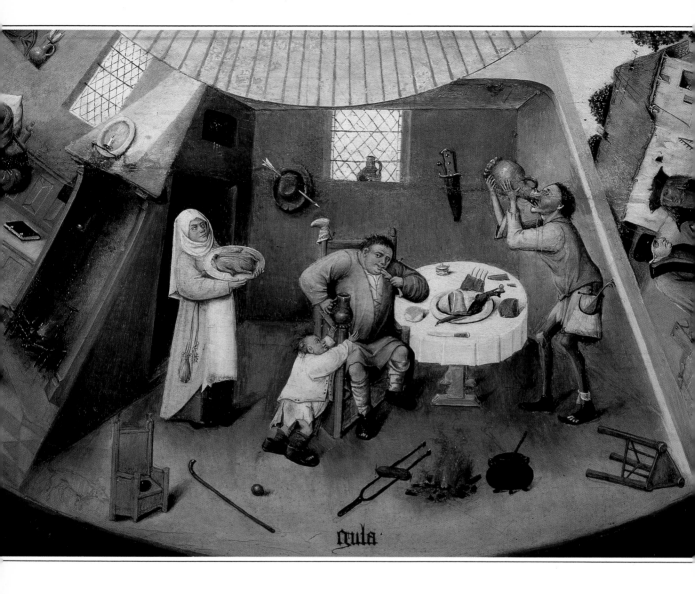

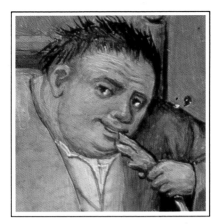

Detail

◁ **Gluttony** *(detail from Tabletop)*

Oil on panel

The subject of this panel could scarcely be more graphically represented. The gross dishevelled figure of the man eating and drinking in the centre, gorging on everything presented to him is the epitome of the glutton. To the left a woman is bringing on another cooked bird while the obese child at the man's knee is obviously greedily begging for more.

A family so greedy that food is their only delight to judge from the bare room, and carrying the suggestion that greed brings poverty and selfishness. This is an early work and the rich variety of imagery which is characteristic of Bosch's mature painting has yet to emerge. Nevertheless, the near caricature of the figures indicates the direction that his work will take.

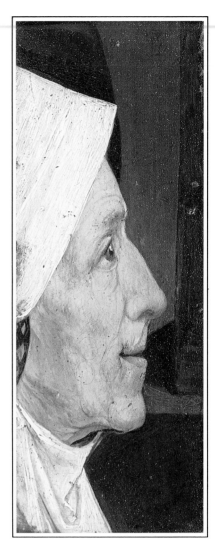

◁ Head of an Old Woman
(fragment)

Oil on panel

This small, keenly observed portrait seems to have been part of a larger composition now lost. It was probably painted about 1500 and is an early example of Bosch's mature style. Although it carries none of the more obvious characteristics of his work, it is generally accepted as being by Bosch. What may surely be said is that it shows a gentle, sympathetic side of his nature and that he had some affection for the sitter, which may suggest that she was a member of his family. Alternatively, what may be seen of the costume and the upward glancing pose may indicate that it was part of an altarpiece and that the subject was in a religious order. All the speculation does not detract from the delicacy of this rare portrait. An earlier attribution of the work to Pieter Breughel the Elder is now discounted.

▷ The Stone Operation (The Cure of Folly)

Oil on panel

At first sight this looks like an ordinary if dangerous operation, curiously being performed in the open air by a surgeon who wears a funnel as a hat. The large, ornate inscription surrounding the picture reads, 'Master, cut out the Stone. My name is Lubbert Das.' It was a common belief in Bosch's day that an operation to remove a stone from the head of a patient would cure his inherent stupidity. The name Lubbert was applied to those with an unusual and identifiable degree of stupidity. What is emerging, however, is not a stone but a flower, and another of the same kind may be seen on the table. These have been identified as tulips, which carried a connotation of folly. The figures of the priest and nun have not been explained, but the closed book on the nun's head and the funnel are symbols respectively of the futility of knowledge in dealing with human stupidity and of deceit in a false doctor. The attribution to Bosch would be somewhat doubtful were it not for the beautiful and characteristic distant landscape.

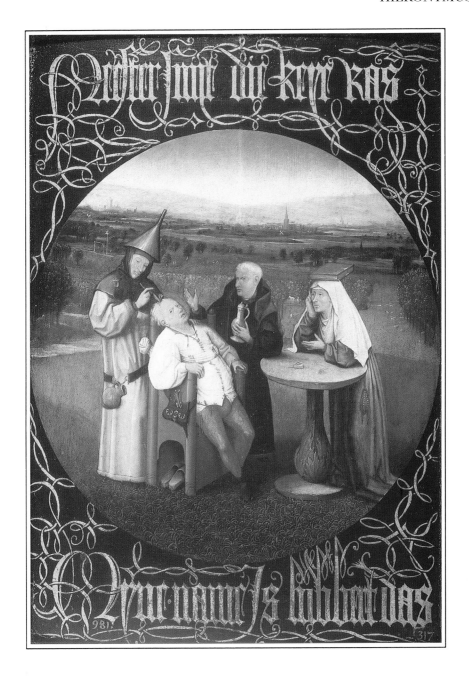

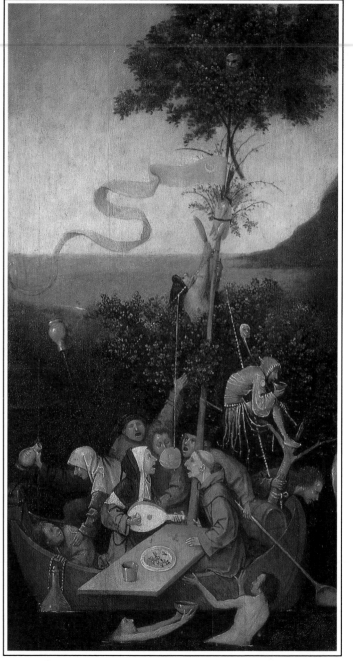

◁ The Ship of Fools

Oil on panel

Little in Bosch's mature work is straightforward representation. Most elements and details are open to a variety of interpretations, many of which are obscure in their reference. Much of the obscurity must be part of a deliberate attempt to make demands on the imaginative power of the faithful and perhaps even more to comment obliquely on the failings of the Church and its clergy. Bosch was, of course, not alone in this; the seeds of the Protestant Reformation were sprouting during his lifetime. *The Ship of Fools*, from his middle period, is full of both obvious and obscure symbolism. The ship was a common symbol for the Church conducting souls to the heavenly port. This boat carries a monk and two nuns, who are all misbehaving with a group of peasants – an unmistakable reference to the moral failure of Church and lay society alike; for emphasis, the owl of evil lurks in the tree mast. Gluttony, indulgence and lust are included, and the whole scene is presided over by a jester fool, whose role is to satirize the morals and manners of the day.

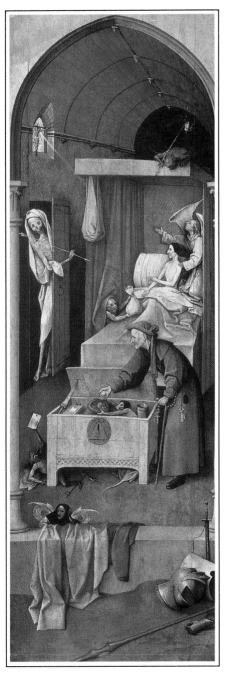

◁ **Death of the Miser**

Oil on panel

Here the moral message is that people will persist in their deadly sins to the point of death. This panel shows a miser on his deathbed still dedicated to grasping more wealth regardless of the gruesome figure of Death, on the left, entering the chamber with a pointing arrow. The miser still puts out a hand to take the bag of gold with which a little demon tempts him. The death chamber is peopled with demons, each representing some aspect of the miser's life; for example, the little cowled and winged demon monk in the foreground who leans on rich clothing indicates the miser's rank which he also must leave, as his Church, in the person of the monk, cynically suggests. The angel behind the miser fails to attract his attention to the crucifix in the window, while another demon waits to torment him from the canopy. In what is perhaps a second image of the miser placing gold in a bag, more demons inside and outside the chest are waiting to provide other mental or physical tortures.

Detail

▷ **The Ascent into the Empyrean**

Oil on panel

In this second Paradise panel the Blessed are being conducted to the presence of God. The course of the afterlife was a medieval preoccupation, and the panels elaborate the human condition from death either to Heaven or Hell. For the Blessed this meant the purgatorial introduction to the ascent to the godhead. In the most dramatic of the panels the chosen Blessed are being carried upwards by angels, ecstatically gazing into the great light bursting through the funnel into which they float. It is an image of great imaginative and inspirational power. It was believed that the panels were intended to form part of a triptych, but the current view is that they are linked panels.

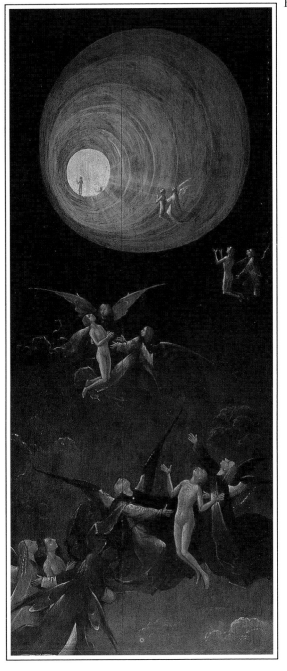

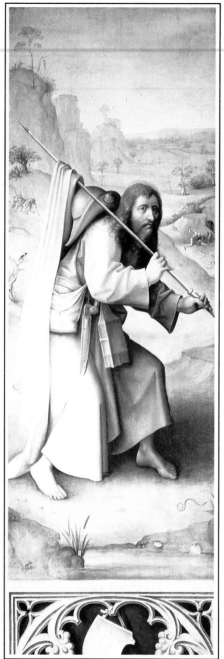

◁ **The Last Judgment** *(exterior left wing)*: **St James the Greater**

Grisaille on panel

Depicted as a pilgrim on the Road of Life, St James the Greater is carrying the symbols associated with him: the staff, the large-brimmed hat and, on it, the scallop shell, his special identification. St James, brother of St John, was the first of the Apostles to be martyred (AD 44). According to legend, after his martyrdom his body was brought from Jerusalem to Spain, where a shrine set up at Santiago de Compostella became one of the great attractions for Christian pilgrims in the later Middle Ages. The landscape in the background carries details of significant reference: on the top left reminding the faithful of death as punishment in life; in the middle left, the long and difficult journey of the blind, halt and lame; and on the right the warning of robbers and murderers on the path through life. This panel, and that of St Bavo (opposite), are painted in grisaille, a method of using grey monochrome that often gives the impression of sculpture. The closed triptych would merge with the surrounding sculpture, giving no indication of the colourful and frightening images inside.

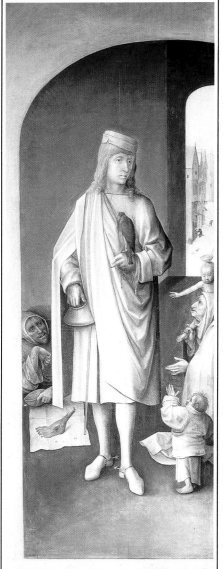

◁ **The Last Judgment** *(exterior right wing)*: **St Bavo**

Grisaille on panel

Bavo was born in Brabant, probably in the late 6th century, and died in 653. He was a rich landowner, made a good marriage, fathered a daughter but led a disorderly life until the early death of his wife induced a dramatic change. He gave away all his possessions to the poor, put himself under the direction of Bishop (and Saint) Amand of Maastricht and devoted the rest of his life to good works, becoming known as the Protector of Flanders. He became a greatly revered saint in the northern Netherlands and a number of churches, including the Groote Kik – the most impressive church in Haarlem – are dedicated to him. In Bosch's grisaille panel Bavo is depicted in elegant dress carrying a hawk on one hand and a purse in the other, representing pleasure and good works respectively, as he gives to the poor, young and old. The significance of the mummified foot and the bowl balanced on the child's head has not been determined.

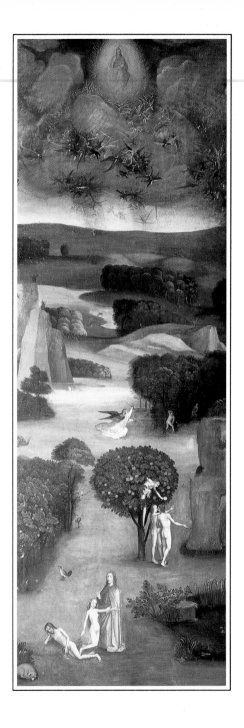

Detail

◁ **The Last Judgment** *(left wing)***: The Fall of Mankind**

Oil on panel

Bosch has set the scene of the Fall in a rich landscape and shows the progress of the action from the lower to the upper levels. At the base the creation of Eve is treated somewhat similarly in design to Michelangelo's composition in the Sistine Chapel, which was painted at about the same time, although the feeling in each work is very different. Bosch, in the waning of the Middle Ages in northern Europe, had a strong sense of the actuality of hell fire, while Michelangelo, in the High Italian Renaissance, placed strong emphasis on the human values in the story. On the second level we see the Temptation: Eve holds out the apple from the Tree of Knowledge to Adam, while a singularly unserpent-like creature, female it may be noted, holds out another. Note too, the ubiquitous owl of evil on a branch to the left. The third level shows the couple driven from the Garden of Eden by a sword-wielding angel. Above the landscape is empty. The fourth level, the sky, shows God driving the rebel angels out of Paradise, in the process of which they are transformed from humans to insect monsters.

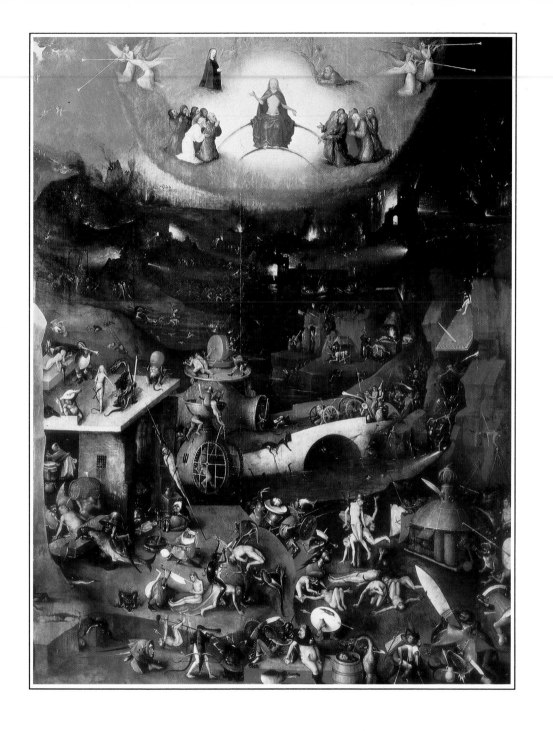

Detail

◁ **The Last Judgment** *(centre panel)*

Oil on panel

This, the largest of Bosch's paintings (163.7 x 127 cm/ 66 x 50 in), is also one of the most revealing and accomplished. The familiar story is clear. Every one of his contemporaries, poor, trusting, illiterate peasants as well as educated burghers, would have grasped the significance of almost all the details and believed the basic message implicitly. But some of the images must have been frighteningly new and distressing, if not actually inducing despair. Other painters had treated the same subject powerfully, but no one, before or since, has had the creative intensity and ability to actualize the dreaded unknown in such fantastic images. This is particularly true in the devils, demons, evil spirits and unnerving monsters that Bosch created to inhabit the nether world. His contemporaries, if they thought he saw (and they would have believed it possible) and accurately represented the monsters and denizens, and the hellish regions they inhabited, must have been convinced that hell was a place to avoid at all costs. The deadly sins are all depicted a number of times and erotic symbolism abounds.

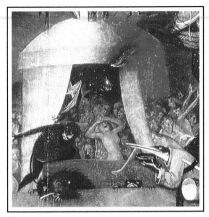

Detail

▷ **The Last Judgment** *(right wing)*: **Hell**

Oil on panel

The ultimate and permanent expectation for the damned, and in Bosch's view that would be most people, will be hellfire, torment, wailing and the gnashing of teeth. It is God's awful prospect for humankind. It was a subject that Bosch treated a number of times, always effectively but most potently, perhaps, only in the right wing of *The Garden of Earthly Delights* (pages 52-61). Here, however, while the images are characteristically Bosch, the total effect does not fully cohere. Nevertheless there are a number of powerful inventions in the details.

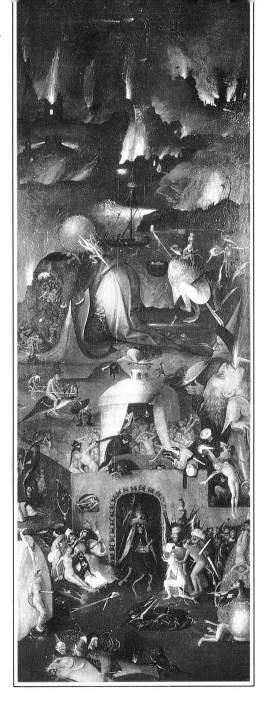

Detail

▷ **Frying Bodies** (*detail from centre panel of* The Last Judgment)

Oil on panel

In this panel of the painting Bosch has created some of his most powerful images. There appears to be no limit to his visual imagination nor any restraint in depicting it. The metamorphosis of one thing into another is a constant device, as can be seen in this and the following illustrations taken from this panel. In the centre of this detail an old woman with lizard-like feet is frying human remains, while two eggs (symbols of sexual creativity) are waiting to go in the frying pan. Behind, another monstrous hag is turning a body on a spit and another body can be seen already prepared. On the right a beetle-like creature is dismembering another figure for the frying pan. This is truly hell's kitchen. Another figure in the foreground, repenting too late, has his hands clasped in prayer while a monster is spitting him for the knife. There also seems to be a mouse metamorphosing into a porcupine – or vice versa.

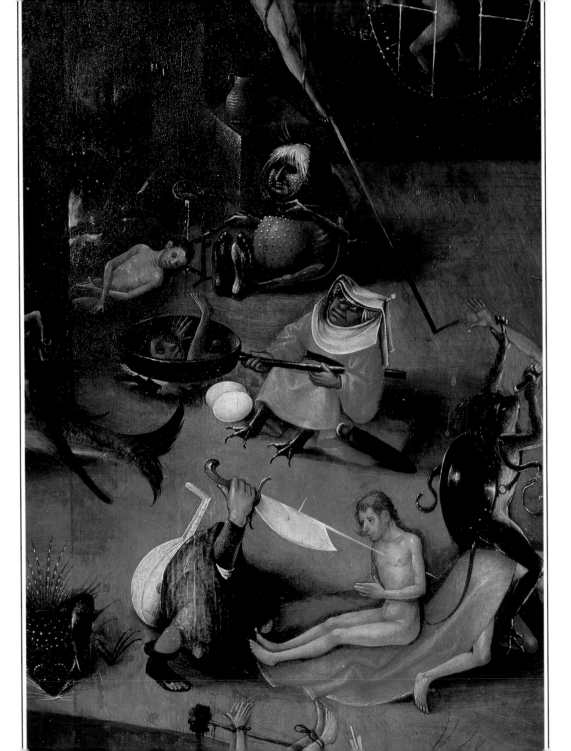

Detail

▷ **The Cask** (*detail from centre panel of* The Last Judgment)

Oil on panel

To the left of the detail shown on page 32 (*Frying Bodies*) a scene of gluttony is represented. Here a gross figure drinks from a cask held up by an almost human demon. A good example of Bosch's creative vision can be seen in the fish monster approaching the table at which the drunkard sits. The fish, a symbol of lewdness, is changing or has changed into a two-legged soldier figure, fully armed but without a body and with legs emerging from its helmet. A different form of the metamorphosis process can be seen in the head of the drunkard, where, on the left, he is being supported by a particularly vicious looking demon. The red shape can be seen as a turban and the head can be seen looking to the left – a familiar child's game. In the background another figure, in the back kitchen, can be seen cooking some more human remains, or is she just pressing their blood into the pot that stands below the boiler?

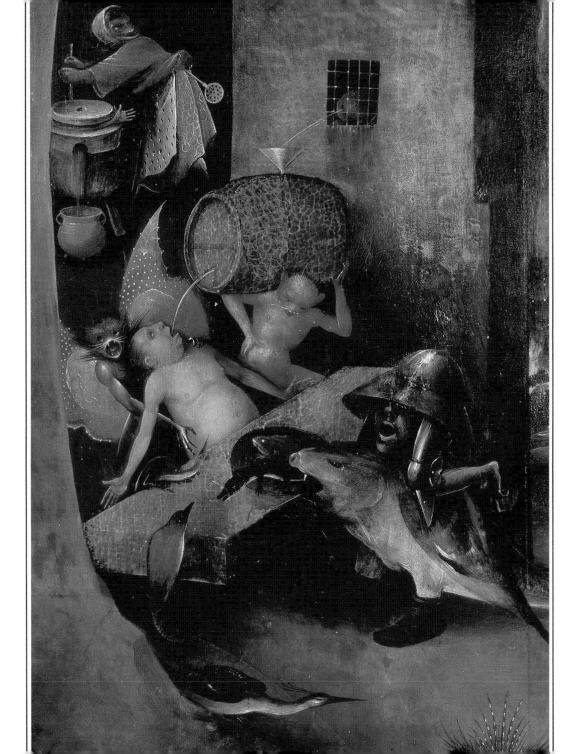

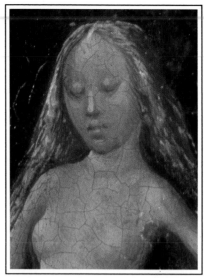

Detail

▷ **A Musical Scene** (*detail from centre panel of* The Last Judgment)

Oil on panel

On the platform above the kitchen a sort of concert is being played for a female who is being embraced by a snake-like monster while a happy dragon looks on. A singularly revolting monster is twanging a mandolin on his head while a duck-like figure wearing hunting boots blows a hunting horn. The woman's long tresses suggest both Eve and the seductress, and she appears not yet to have become aware of her undoubted fate. To the left another female figure reclines in seemingly unconcerned contemplation of a slimy demon who is approaching her couch. Another monster is coiled behind her. The whole of this scene comments on the seductive effects of music and the female form.

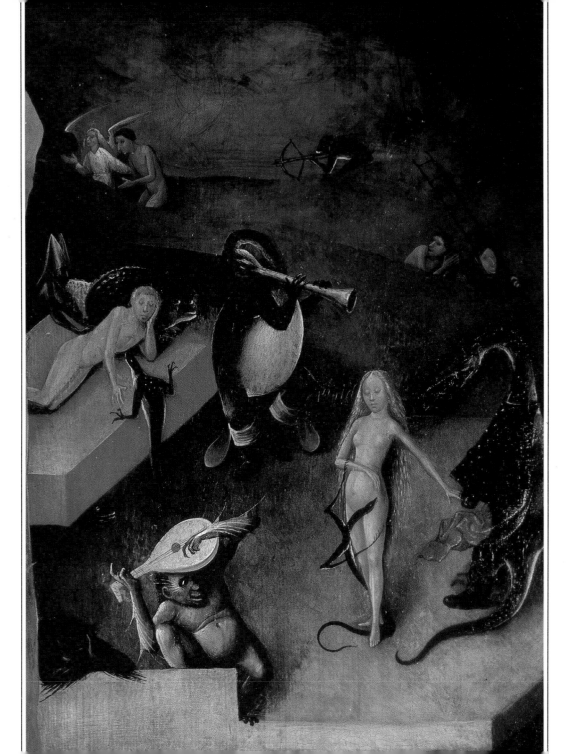

▷ **The Urn** (*detail from centre panel of* The Last Judgment)

Oil on panel

A detail close to the *Frying Bodies* (page 32) shows an arrow-pierced figure prepared for roasting on the spit while others hang like cured hams behind the fire. In the centre of the detail there is a blue painted metallic urn-like object in which naked unfortunates are being 'processed' by soldiers. It is difficult to determine precisely how it works but it looks extremely unpleasant. Behind this a green pot lies on its side and on it is a platform on which other unfortunates are towing a red object that suggests a millstone and is controlled by demons. Near the bottom of this panel there is a figure composed of only a head on legs, similar to one seen in the detail on page 34 (*The Cask*). These 'gryllos', as they are called, appear frequently in Bosch's work, but their precise significance is not known.

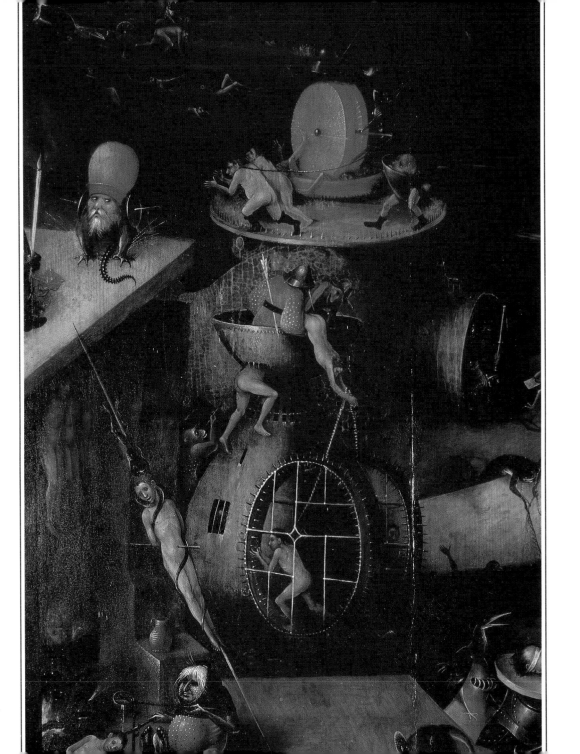

Detail

▷ **Monsters with Knife** (*detail from centre panel of* The Last Judgment)

Oil on panel

In the bottom right corner of the panel are a group of monsters carrying a large knife, whose phallic symbolism is unmistakable. The funnel – the familiar symbol of deceit and intemperance – can also be seen in this complicated ensemble. The demons are varied. One is transforming from a fish into at least a scaly human leg while another, wrapped in the red shape, has a sharp beak and a keen eye. There is also a lizard leg emerging from the group. Another beaked figure is carrying a basket containing a human being and a demon. It is difficult, if not impossible, to explain all the forms that Bosch invents in terms of a Christian symbolism and it is very likely that some have no more than his creative imagination as their inspiration.

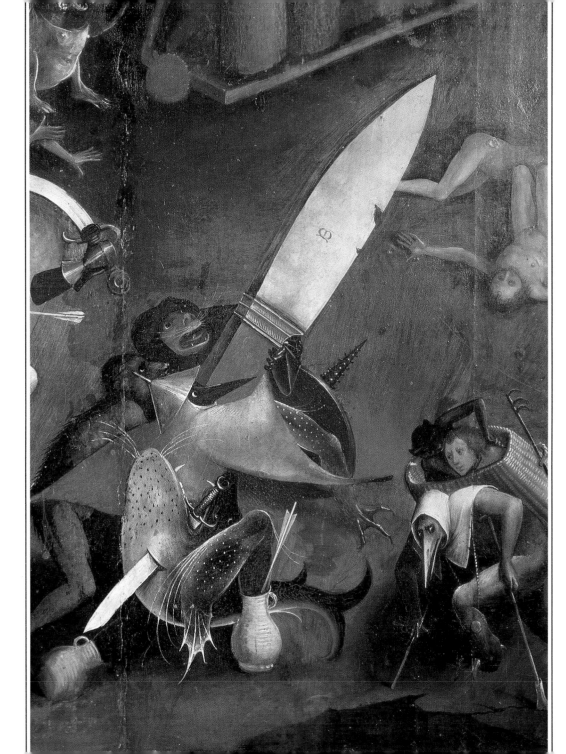

Detail

▷ **The Haywain** *(exterior panels)*: **The Road of Life**

Oil on panel

The symbol of the pilgrim on the precarious, threatening road of life was common in medieval painting. The two outer wings of *The Haywain* depict a poor, fearful and emaciated middle-aged peasant, with his possessions strapped to his back, glancing behind him at a scene of robbery while fending off a vicious dog. He is about to step on a bridge that is too thin to carry even his weight – a reminder that the next step in life may bring disaster or death. On the right of the painting carefree peasants dance to a bagpiper seated under a tree. In the background a crowd is gathered for a hanging while nearby stands a tall pole surmounted by a wheel on which the bodies of executed criminals were displayed. Altogether it is a scene of threat and fear. Although the work is badly painted and probably all by assistants, the design is certainly by Bosch, who used it in a later circular panel (page 77).

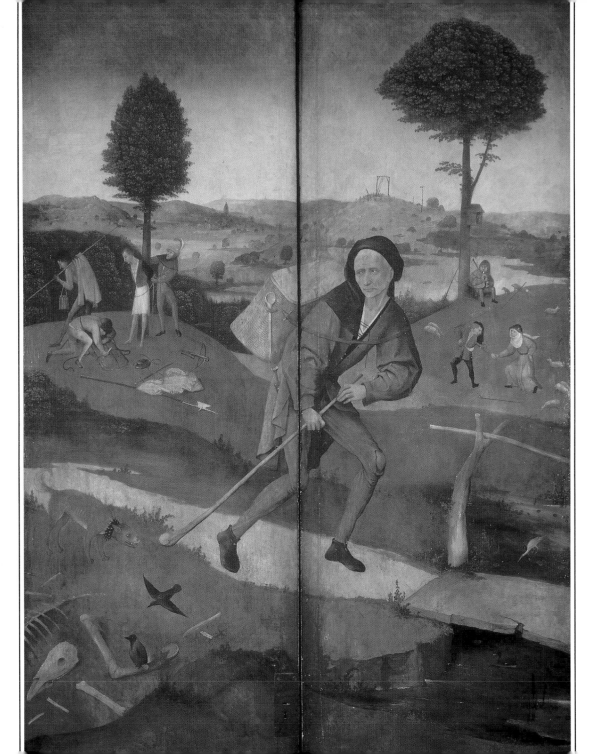

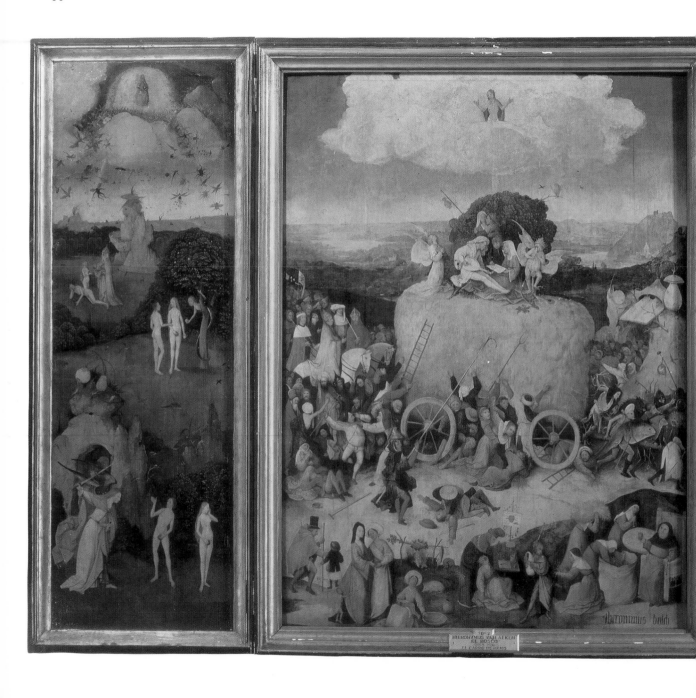

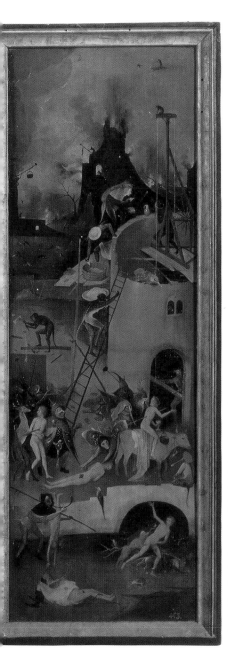

◁ The Haywain

Oil on panel

We have seen, in many of the subjects so far considered, Bosch's warnings of the wages of sin. His *Last Judgment* (pages 24–41) has a particularly gruesome version of the Fall and the subsequent lodgings of the damned in hell. His unique imaginative powers were at their most characteristically effective in such works. But the paintings by Bosch with which most people are familiar are those concerned with the lifetime sins themselves. The two works most representative of this aspect of Bosch's work are *The Haywain* and *The Garden of Earthly Delights* (pages 42–61). There are two versions of *The Haywain*, both in Spain, one in the Escorial Palace and one in the Prado Museum. Although not identical, they are almost so and it is not known which is the original and which the copy; indeed they could both be originals. The subject, a central concern for Bosch, is his belief that the follies and sins of humankind are endemic and that hell is our ultimate destiny.

Detail

▷ **The Haywain** *(centre panel)*

Oil on panel

Bosch shows as a triumphal progress the passage of a simple hay wagon, seen centrally placed, as it moves through a fantasy landscape towards its ultimate hell. The cart is towed by demons and in the following retinue can be seen the 'great and good' of this world, including an emperor (possibly Maximilian I of Germany) and a pope (convincingly identified as Pope Alexander VI, the notorious Roderigo Borgia). All those with the cart regard it covetously, some snatching handfuls of hay and fighting among themselves. It seems curious that a hay cart should figure so prominently in an important triptych unless one knows that it was a traditional symbol for God's goodness. Being of little worth in itself, it also emphasizes the futility of gathering worldly possessions. A contemporary proverb was 'The world is a haystack; everyone grabs whatever he can.'

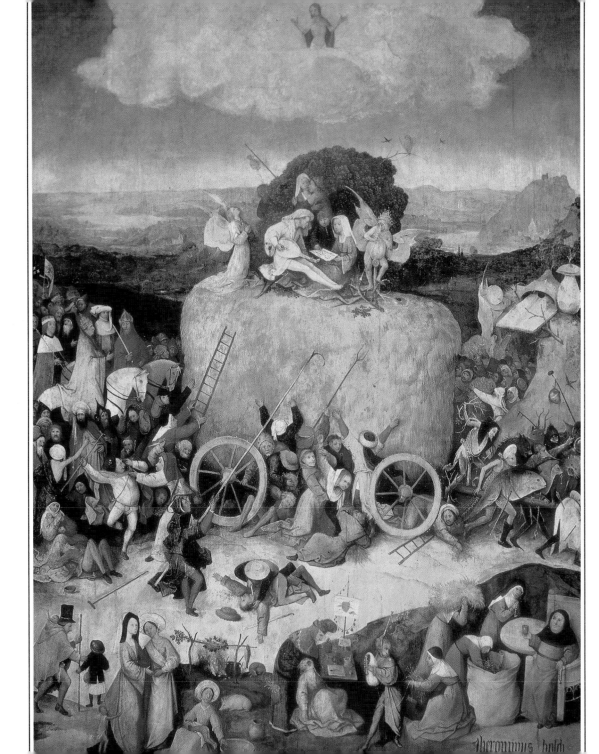

Detail

▷ **The Lovers** (*detail from centre panel of* The Haywain)

Oil on panel

The central feature of the panel is the scene on the top of the haystack. In a grouping reminiscent of paintings of the Holy Family, two pairs of lovers illustrate the ubiquitous sin of lust. As they follow the music, a symbol of self-indulgence, in this idyllic vignette their souls are being contested for by the praying angel on the left and by the devil's seductive music on the right. The devil is an endearing creature, significantly closer to the lovers than the angel, with butterfly wings, circular genitals and a peacock-eye tail. Behind the more elegant seated lovers, a second pair of peasants are kissing in the bushes in a bucolic prelude to a coupling. This little scene is depicted with a sympathy that is at variance with almost all the emotions displayed elsewhere and devoted to the sins of the flock. There the emphasis is on this world rather than the afterlife, although a warning that pain may accompany pleasure is indicated.

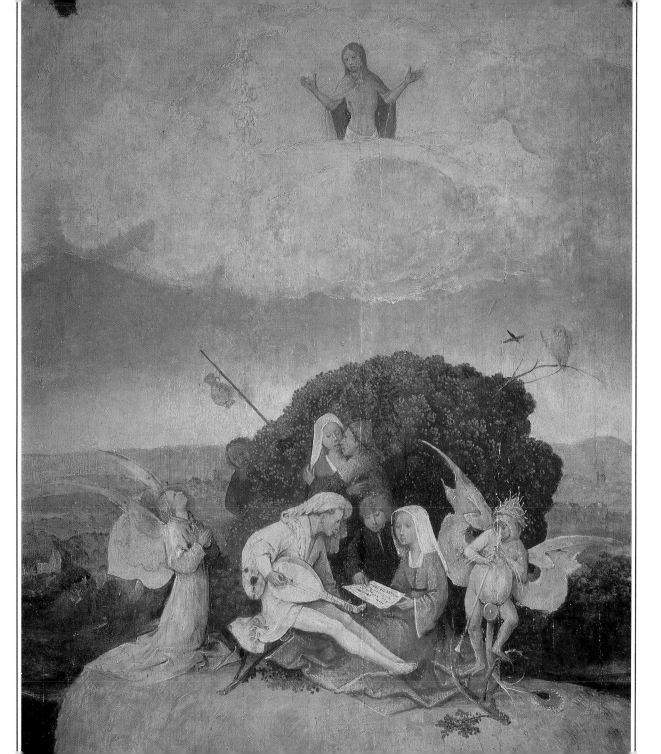

Detail

▷ **The Haywain** *(interior right wing)*: **Hell**

Oil on panel

The progress of the haywain, conducted by demons in human, animal and fish-like forms, leads inexorably to hell. In this typically Boschian example poor damned, naked souls, the protection of clothing removed, are suffering torments at the hands of vicious demons and mythological animals, such as the antelope with scaly human legs. There is fire and destruction and the gaping maw to the lowest regions of hell in the bottom right corner. Although a dolorous and frightening scene, it is perhaps less effective than other examples and again shows the work of assistants, who, using the same imagery, are not able to create the same power and conviction that Bosch himself achieves. The scene is nevertheless full of symbol and suggestion. Look, for example, at the man lying on the ground with a toad devouring his genitals, suffering the fate of all lechers. Since the toad looks at first sight like a fig leaf, it carries, perhaps, echoes of the Fall of Man.

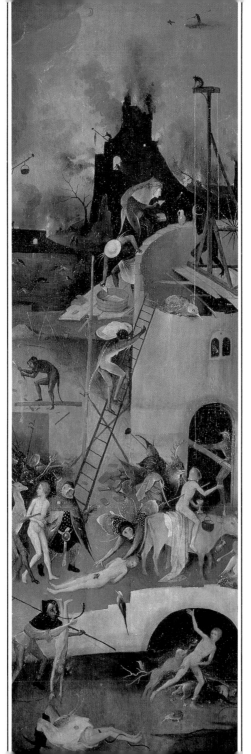

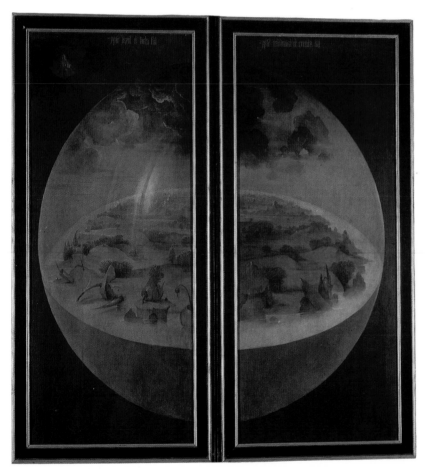

◁ **The Garden of Earthly Delights** *(exterior panels)*: **The Third Day of Creation**

Grisaille on panel

Bosch's triptych, known alternatively as the *Earthly Paradise*, is the central and most familiar of all his works. It is from this triptych, and especially from the central panel, that most of the images generally known are taken and it is where his unique fertile imagination is at its most creative. Unique is a much overused word, but with Bosch there is a variety and power in his pictorial imagery that no other painter before or since has achieved. While it is perhaps true that the appreciation that his work is accorded in our time is different from that which his contemporaries felt, there is a fascination in the study of the minutiae over the whole surface of his paintings that never diminishes. As with the *The Last Judgment*, the grisaille panels of the closed exterior wings do not prepare one for the explosion of colour and imagery they conceal. Depicting the world on the third day of Creation, it is a sombre evocation of the conversion of the Great Void into the Earth World.

The Garden of Earthly Delights

Oil on panel

▷ *Overleaf pages 54-55*

The open triptych consists of the Garden of Earthly Delights in the centre, the Earthly Paradise on the left, and on the right, in case viewers believe that they could get away with the excesses depicted in the central panel, is Hell, the most powerful and distressing of all Bosch's treatments of the subject. In both *The Haywain* (pages 42-51) and *The Last Judgment* (pages 24-41) Bosch is reminding the faithful of the pain that will ultimately and permanently engulf the sinner. In this central panel, however, the sins of the flesh seem to be celebrated and the participants uninhibited, unselfconscious and joyful, betraying no sense of guilt. The scene is in high tone and bright, fresh colour. Erotic symbols and sexual activity of considerable gaiety abound. Bosch, unusually, seems not to condemn but to participate, and we are obliged to consider for whom the painting was intended. Although it may seem unlikely to have been for a church, the three panels taken together are not inconsistent with the other Bosch triptychs, and it may have been intended for a minor religious sect that believed in 'free love.'

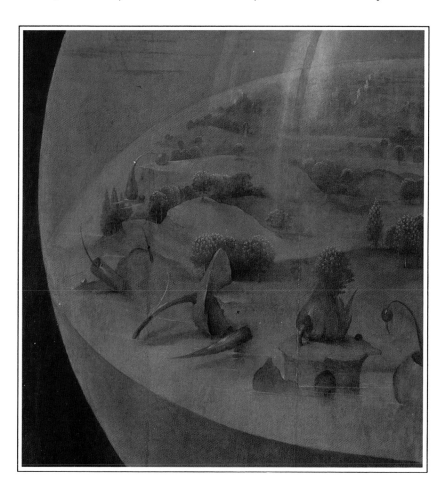

Detail of exterior panel, opposite

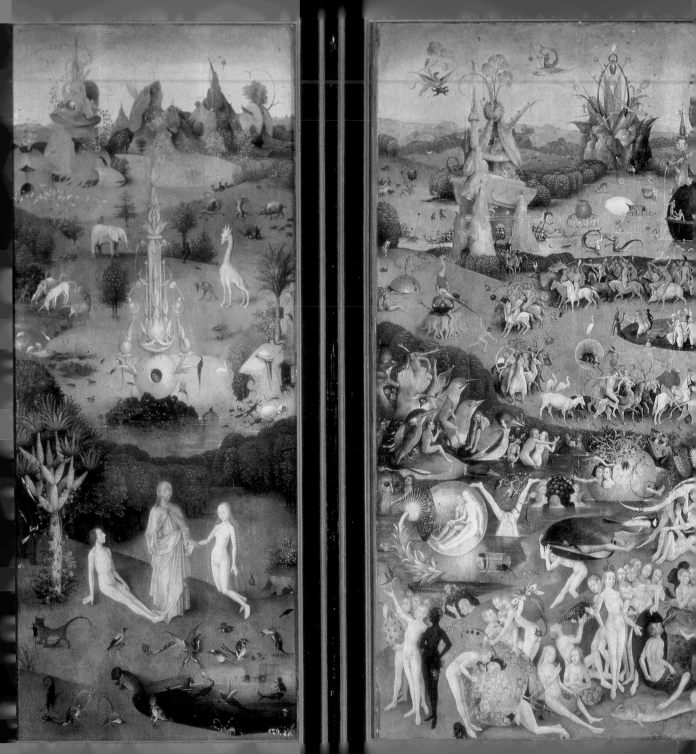

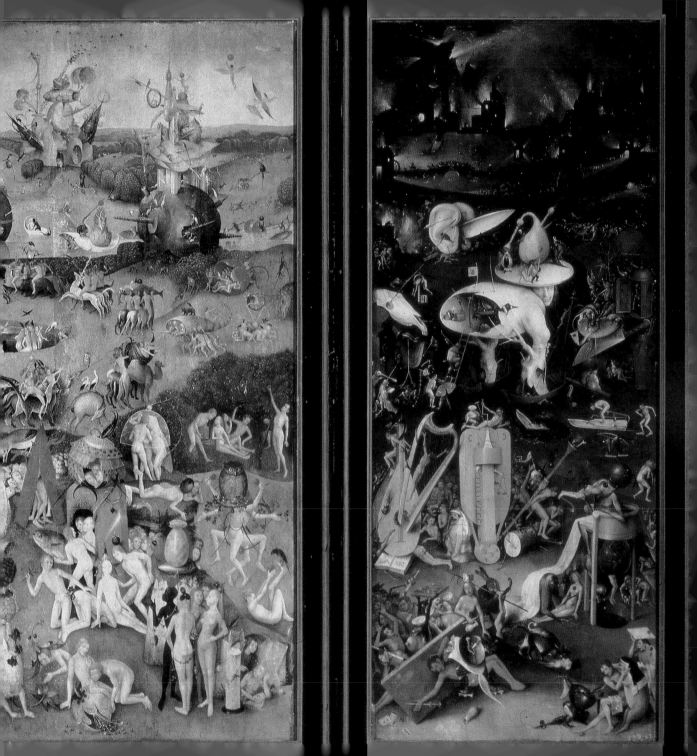

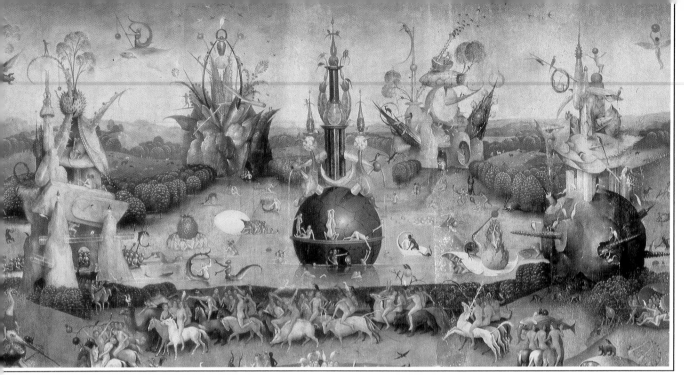

Detail

▷ **The Garden of Earthly Delights** *(centre panel)*

Oil on panel

In a park-like landscape under a clear sky, surrounded by or inhabiting curious plant forms, the pale, naked human forms engage in the joyous battle of the sexes in a dreamlike contemplation of love, sexually enticing gestures or postures and in explicitly sexual embrace. Accompanying them are strange fruits, spherical or ovoid shapes and, in the distance, five structures, strange accumulations of forms, on or in which further sexual acrobatic exercises can be seen. In the centre a circular pool in which a group of naked females disport themselves is being circled by male riders on a variety of beasts. A number of giant birds, including the warning owl, and other curious animals are also part of the scene. A fish, a symbol of lewdness, is in the foreground. The curious overall effect of this pastoral orgy is of peaceful innocence and a real delight. The warning scene on the right wing (page 61) makes it all the more potent.

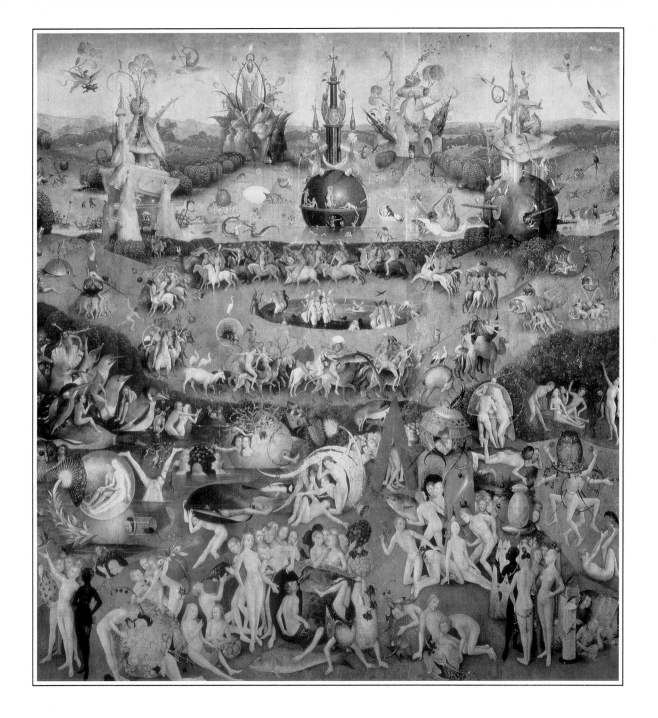

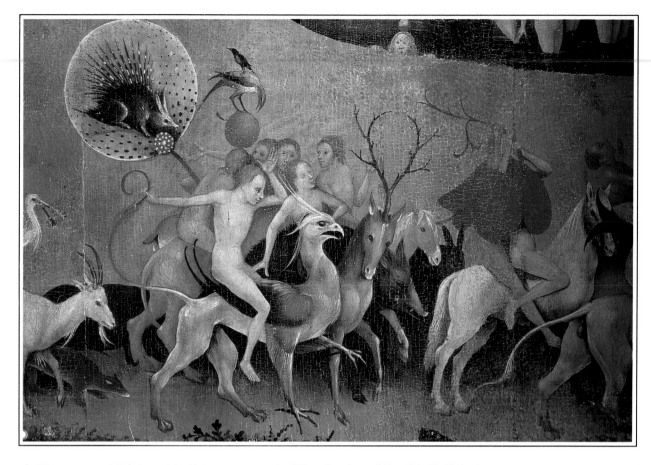

△ **Horses and Riders** (*detail from centre panel of* The Garden of Earthly Delights)

Oil on panel

In the circular pool in the centre of the painting women are swimming, standing or disporting themselves. There are no men. Around the pool men riding horses and other fabulous animals, such as the gryphon-like creature seen in the centre here, form a continuous parade. This is the beginning of lust, the start of the Fall, and Bosch is noting the nature of sexual attraction. In this detail the men are all alert and self-conscious. At the top a woman is peering out of the pool with the temptress Eve's symbol of the apple, the Forbidden Fruit, perched on her head. Elsewhere other women are preparing to leave the pool to come to the men rather than the men to them. It was the medieval belief that women were the eager receptive vessels of lust and the original cause of men's fall from grace. It is Bosch's most positive statement of the pleasure and pains of sexual attraction.

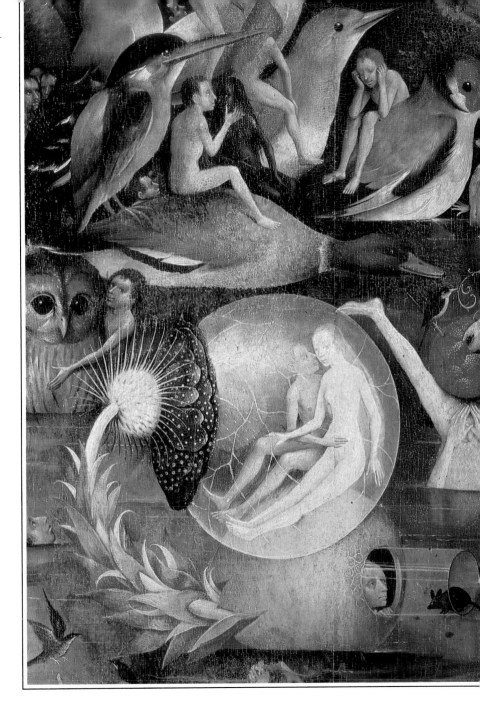

▷ **Couple in a Bubble** (*detail from centre panel of* The Garden of Earthly Delights)

Oil on panel

Of all Bosch's large triptychs, the centre panel of this painting is most packed with incident and with symbolism, both mainly sexual. Much of the symbolism is still not understood despite the intensive work of many scholars over the last nearly 500 years. What has been discovered is often of such arcane reference that to explain it requires many words. Nevertheless, every detail provides exciting and interesting speculation. Some of the symbols that have been noted elsewhere can be seen here: the owl of knowledge and evil, rotting or exotic fruit, phallic fish, filthy rats. Of all the sins the most deadly is lust, and here we find it everywhere: in the foreplay in the bubble; in the man holding his genitals, a symbolic rotting raspberry between his legs; and in the birds, the reminders of flight, both to the heavens and in emotion.

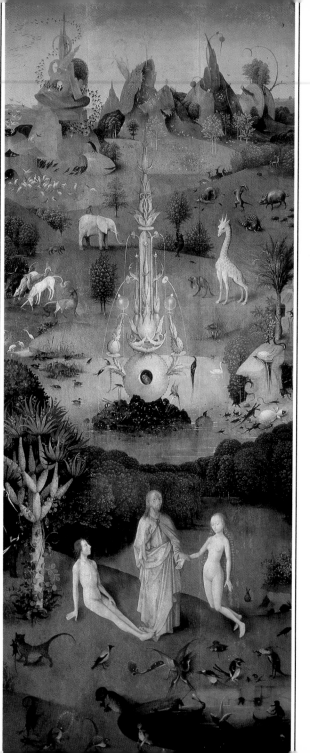

◁ **The Garden of Earthly Delights** *(left wing)*: **Paradise**

Oil on panel

The left inner panel completes the story begun on the exterior panels by illustrating the last three days of Creation, during which the Earth teems with animals, some recognizable, like the giraffe, elephant and deer; some fabulous inventions, like the unicorn. In the centre a dramatic Fountain of Life in a delicate pink rises from a rocky islet in the centre of a lake. To the right some weird water creatures climb a bank, which transforms itself into a Dali-like head, while to the left ducks and herons create a sense of nature at peace. Below this scene a fierce and fabulous Tree of the Knowledge of Good and Evil stands close to the figures of Adam and Eve. God appears here youthful and in the image of Christ, suggesting two parts of the Trinity in One. It is the moment when God says 'Be fruitful and multiply, replenish the Earth and subdue it.' It might be noted that in the central panel (pages 56-59) there are no children and the inhabitants are engaged in other pursuits than subduing the Earth – indeed, the giant fruits suggest the reverse.

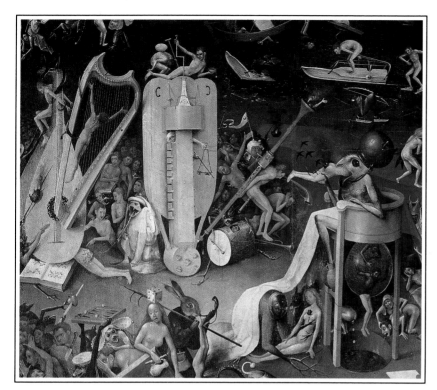

◁ **The Garden of Earthly Delights** *(right wing)*: **Hell**

Oil on panel

Bosch's presentation of hell is nowhere more powerfully or inventively depicted. The colour is sombre and the elements, in the main, are not found elsewhere in Bosch's treatment of the subject. The central feature, an egg-like body on two legs that float in two boats and with a wistful backward glancing head wearing a flat tabletop hat, has never been satisfactorily explained, although the egg is a key symbol for sexual creation. Others are less obscure. For example, the two ears with a knife between them is an unmistakable phallic construction; the ears themselves are symbols for gossiping, and the knife a punishment for evil acts – altogether a neat message. There are examples, too, of anal eroticism, self-abuse, defecation and dismemberment. The sins that cause this suffering may also be discovered: for example, sloth (a man visited in bed by demons), gluttony (a man being made sick of the food he has engorged) and pride (a woman admiring herself in the mirror backside of a revolting demon).

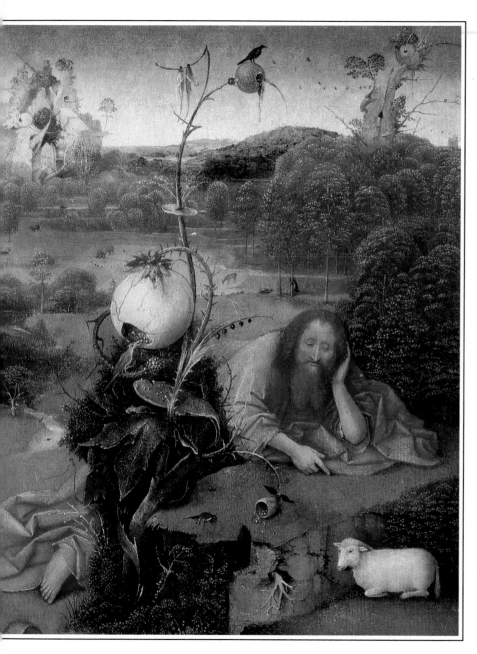

◁ **St John in the Wilderness (Meditation)**

Oil on panel

St John the Baptist was the son of Elizabeth, cousin of Mary, the mother of Christ. Known as *precursor Christi,* he prophesied the coming of Christ and is often associated pictorially in his youth with Christ. It was he who later baptized Christ. Also traditionally associated with the Lamb of God, the symbol of the Redeemer, in Bosch's painting St John is depicted in the wilderness lying in meditation and pointing to the Lamb, quietly seated in the bottom right. Again the traditional, endemic temptations of the flesh are indicated by the exotic luscious fruit, symbols of carnal pleasure, growing close to the Saint. The presence of monsters in Bosch's paintings is not always explicit, often seen only in that form of metamorphosis characteristic of modern Surrealism. One example is the elongated rock on which St John is leaning, which transforms at its left into a rat-like head, the rat being another symbol for sex as well as for general filth and lies against the Church.

▷ St Jerome at Prayer

Oil on panel

Jerome was born about AD 342 and died in Bethlehem in AD 420. He studied philosophy at Rome and became one of the most learned of the Latin Fathers of the Church, a great biblical scholar who revised the Latin version of the New Testament and worked over or translated the whole Bible, known since the 13th century as the Vulgate. He was ordained a priest but did not exercise his priestly office. In 374 he retired to the desert near Antioch and spent some years among the hermits. While there he was visited by temptations and lustful visions of the flesh. Most representations of St Jerome show him in a state of penitence in the desert. Bosch's painting depicts Jerome as a reclining praying figure, having cast aside his cardinal's robe and hat, which are often shown as indications of both his service to the Church and his rejection of the priestly office. Around him are familiar symbols of the bodily temptations: broken fruit, an evil smelling swamp, indicating decay and corruption, and a lurking owl. There is also a small dog-like creature at the bottom left, which probably represents a lion, Jerome's symbol.

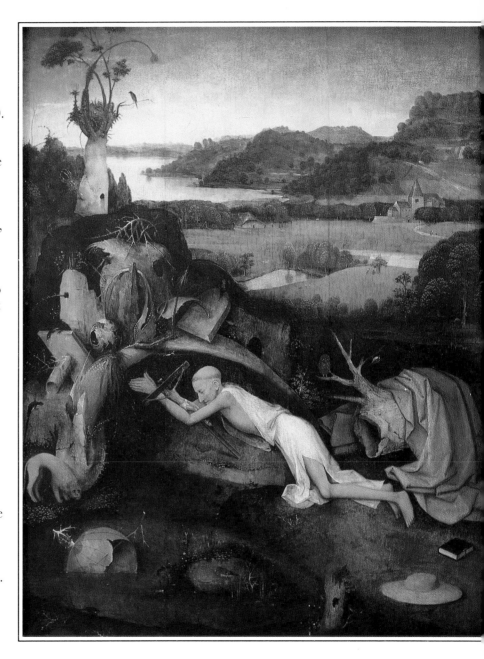

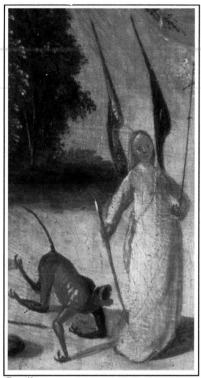

Detail

▷ **St. James and the Magician**

Oil on panel

Much mythology surrounds the story of St James the Greater (see page 24). Among these legends that of the magician Hermogenes was well known in the Middle Ages as reflecting the power of the Saint to counter magic with miracles. Briefly, the story goes that James was preaching and was approached by the Magician's assistant, who was sent to confound the Saint's teaching. But James converted the assistant. The Magician, justly infuriated, cast a spell on the assistant, who, in turn, appealed to St James to free him. This James did. The Magician then sent demons to torment James. Eventually, after much toing and froing, St James converted Hermogenes, who, in his turn, performed many miracles; a salutary story illustrating the power of the early saints. The medieval belief in the actuality of the demon world is demonstrated here by the convincing setting and costume, particularly of the enthroned Magician and of his apparently 'conversational' relationship with the demons. St James, with his angel and the retreating demons, can be seen on the upper left.

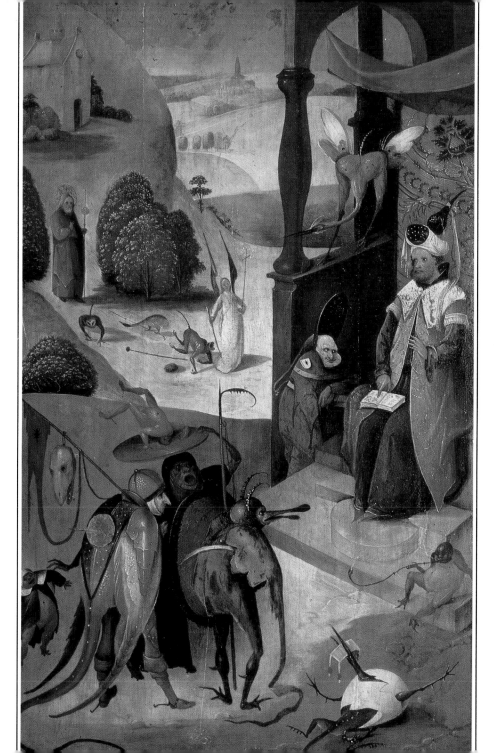

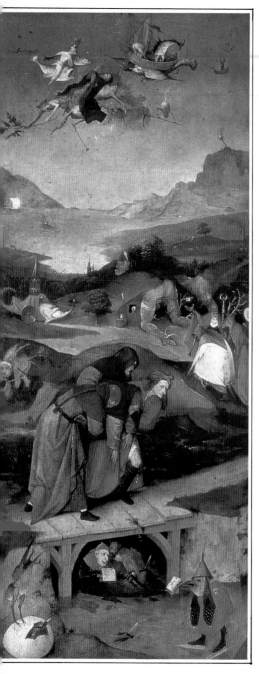

◁ **The Temptation of St Anthony** *(interior left wing)*: **Flight and Failure of St Anthony**

Oil on panel

The life of St Anthony is a recurring theme in Bosch's work. Although all attributions are to a degree doubtful, this triptych is generally accepted as one of Bosch's finest late works. St Anthony, as described in the *Lives of the Fathers* and the *Golden Legends* – two of the main sources for the lives of the early churchmen and the Church, both available in Bosch's day – was a notable example of the overriding need for all humankind to resist the temptations of the world, to be at all times suspicious that things may not be what they seem and to learn that failure to recognize this may lead to damnation. This panel shows that while at prayer St Anthony is attacked by demons, who beat him and leave him for dead. In the central episode of the panel he is rescued by two hermits dressed in the garments of the Antonite Order. The fourth figure in the group, it has been convincingly argued, is a self-portrait. At the top of the panel St Anthony has returned to the desert in which he lives, where he is again attacked by demons, who toss him high in the air.

▷ **The Temptation of St Anthony** *(central panel)*

Oil on panel

St Anthony was born in Egypt about AD 250. When he reached maturity he sold all his possessions and retreated into the Egyptian desert, where for the next 20 years he followed a life of dedicated Christian contemplation in total seclusion in an old ruin on the top of a hill. In 305 he was persuaded to leave the wilderness and with some companions he formed the first monastery, and thus is regarded as the founder of the monastic idea. Living in isolation in the desert had not meant that he avoided the temptations of all the deadly sins, but his sturdy resistance made him a great example for Bosch and his contemporaries. In this splendid, richly painted panel St Anthony is shown centrally placed and surrounded by images of the great sins depicted with Bosch's mature, uniquely inventive vision. When St Anthony was over 100 years old he visited Alexandria for a disputation with the Arians, but, anticipating his death, soon returned to his desert home, where he died in 365

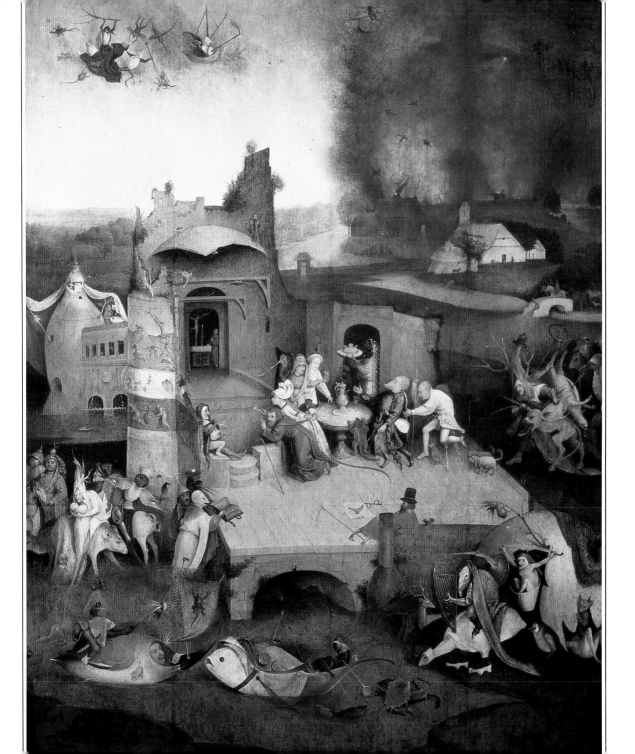

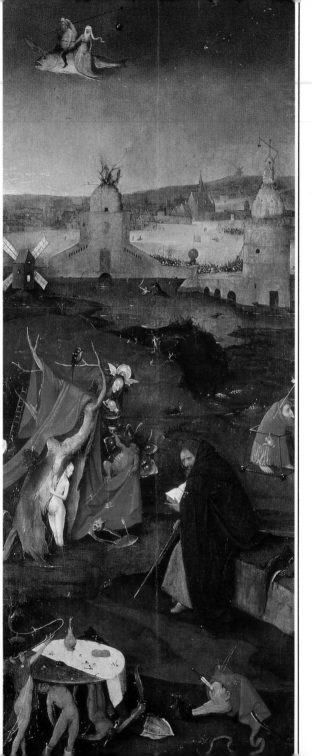

◁ **The Temptation of St Anthony** *(interior right wing)*: **St Anthony and the Devil Queen**

Oil on panel

While leading a life of meditation in the desert, the Saint was pursued by one of the most powerful of all the temptresses. In the Garden of Eden the Fall of Man began with Eve and the awareness of sexual attraction as she and Adam became conscious of their naked bodies. The Devil Queen appears to Anthony naked and shielding her pubic area with a coy, self-conscious attraction. Anthony averts his eyes, only to have them fall on a devil's feast to which he is being beckoned. In the background the Devil Queen's fair city stands ready to welcome him should he turn again. The dragon fighting a human in the moat and the flames erupting from the round tower suggest the disguised hell from which the Devil Queen has come. The Dutch windmill, an incongruous note, is a reminder of ergotism, an illness caused by rotten grain and known as St Anthony's Fire, as well as an indication of the deceptive possibilities of the mundane and ordinary.

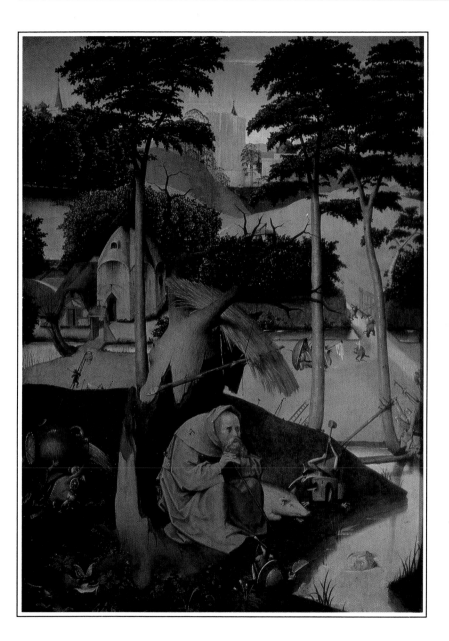

◁ **The Temptation of St Anthony**

Oil on panel

In this small panel Bosch shows the Saint reflecting and meditating in a curiously constructed hut in a sunny pastoral setting. The Saint's own separation from the world is in contrast to the well-being around him. A variety of mechanistic demons and monsters surround him, but his eyes are fixed on the distance. The demons and the treatment of the landscape have given rise to doubts about the authentication of this work to Bosch. Although there are symbols that Bosch uses, there is some justification for doubt. However, Bosch is so individual a painter, using imagery that is essentially his own, that it is difficult to think who else might have painted this panel. While Pieter Breughel later used some of the same subjects and symbols, his technical treatment is so different that the painters are rarely confused.

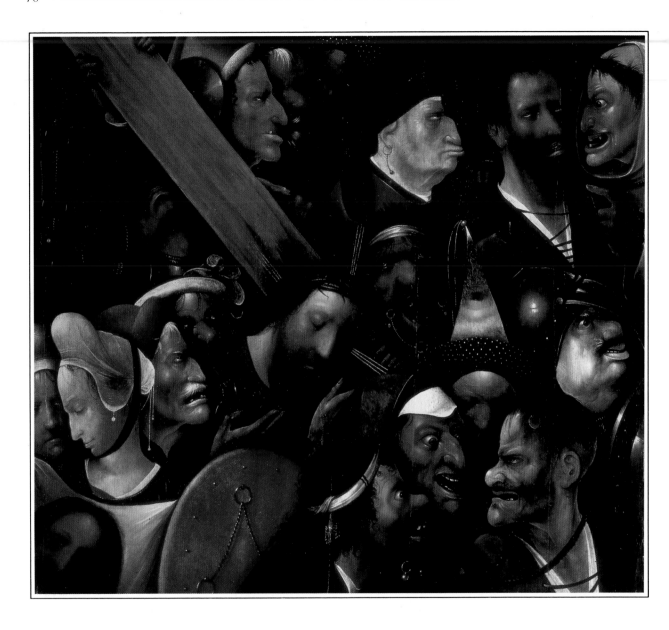

◁ **Christ Carrying the Cross**

Oil on panel

In what is close in character to a cinematic close-up, Bosch has produced here a remarkably dramatic evocation of turmoil on the road to Calvary as well as introducing the powerful effect of caricature. The only two heads treated with simple dignity, noticeably at variance with all the others, are those of Christ and St Veronica. The variety of expression on the faces of the mob invests the painting with its power to evoke a great sympathy with the quiet submissiveness in the central head of Christ. The two thieves to be crucified with Christ are included, the bad thief in the bottom right corner snarling viciously back at his tormentors; and, in the upper right corner, the anguished, repentant thief taunted by a hideous priest. The strength of the drawing and the sense of light in the painting indicate that this is a work from Bosch's last period.

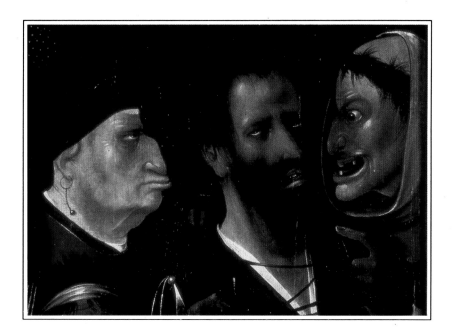

△ **The Repentant Thief** (*detail from* Christ Carrying the Cross)

Oil on panel

The four most significant figures in this crowded panel are Christ, Saint Veronica (page 74) and the two thieves who are to be crucified with Christ. They have appeared frequently in Bosch's depiction of the story of Christ's last days but here they are given particular significance. There is little depth in the painting, all the heads being apparently on the same plane, allowing Bosch to express the great variety of emotion, recognizable to all onlookers, in the faces of the participants. The repentant thief is apart from the viciousness, and with upturned eyes and anguished features, as becomes the penitent, pales as he contemplates his fate. This is being outlined in graphic detail, it seems, by the fiendish, repellent priest at his side while a stern self-righteous citizen urges him forward.

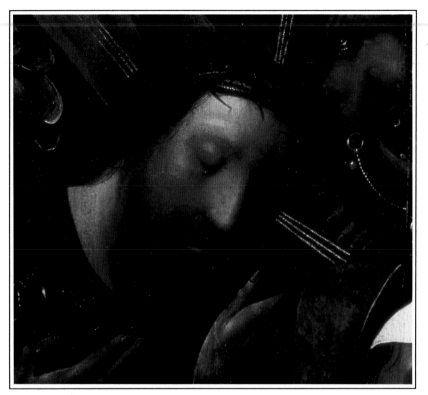

◁ **The Head of Christ** (*detail from* Christ Carrying the Cross)

Oil on panel

In Bosch's crowded close-up Christ's head is emphasized by the cross itself, the only straight line form in the painting. It seems like beams of light rather than wood illuminating his head and provides the source of the light for the subtle and carefully drawn modelling. In the rest of the painting, except for the head of St Veronica (see page 74), the modelling is coarse and the lighting inconsistent. In the bottom left corner there is another head of Christ, this time with open eyes and a strong feeling of compassionate life emanating from them. The contrast between the Christ accepting his fate and the everlasting life that St Veronica has captured on her veil is typical of the oblique manner in which many medieval paintings carry their messages.

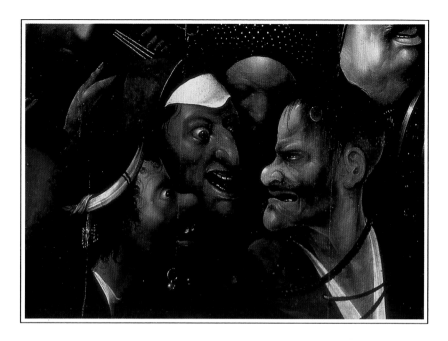

△ **Taunting the Bad Thief** (*detail from* Christ Carrying the Cross)

Oil on panel

This close-up of one head reveals how effectively Bosch can represent the vile and brutal in a remarkably explicit form through the use of distortion. His demons and monsters are inventions that carry great visual authority. Here recognizable human features are presented at the limit of conviction by his acute observation of facial expression. This man is nose to nose with the defiant thief and sheer delight in hate shines from his staring eye while, deafeningly, he shouts taunts and probably obscenities. Is it not also possible to discern the relief of 'There, but for the Grace of God, go I'?

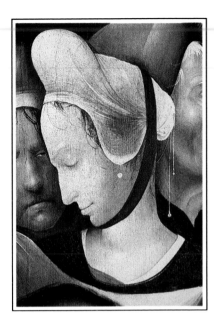

△ **St Veronica** (*detail from* Christ Carrying the Cross)

Oil on panel

According to legend, the apocryphal figure of St Veronica met Christ carrying his cross on the way to Calvary and offered to wipe his brow with her veil. As a result his features were transferred to the veil. This cloth was reputed to have been preserved in Rome from about AD 700 and was, indeed, exhibited in St Peter's in 1854. Since St Veronica did not appear to exist in the Bible and it has also been suggested that her name was corrupted from *vera icon* (true picture), the story has no longer any acceptance. Nevertheless, it was a popular myth, providing a relic similar to the Turin shroud. In Bosch's painting both Christ and St Veronica seem quietly withdrawn from the strident scene surrounding them. Her portrait is just above the cloth she is holding, which bears the picture of Christ, not a mere shadow.

▷ **Christ Crowned with Thorns**

Oil on panel

The Imitation of Christ by Thomas à Kempis, written in the early 15th century has been one of the most influential and widely read books of Christian guidance. As its name suggests, it outlines how the Christian should imitate the life of Christ, especially in the calm acceptance of ills that are received from others. The scenes of Christ's Passion include the placing of the crown of thorns on his head and the taunting of 'the King of the Jews'. In this portrayal of the scene Bosch shows Christ, surrounded by four tormentors to whom he is paying little attention, gazing quietly, almost reflectively directly at the viewer as if confirming the unimportance of his physical torments. Bosch would have reached manhood as à Kempis's book became popular and it has been claimed that this painting is a direct expression of the book's message. Like Bosch's *Christ Carrying the Cross* (pages 70-74), this painting contains little depth, the figures being crowded towards the picture plane achieving maximum pictorial impact. As in most of Bosch's paintings, as well as those of his contemporaries, the figures are in the dress of the day.

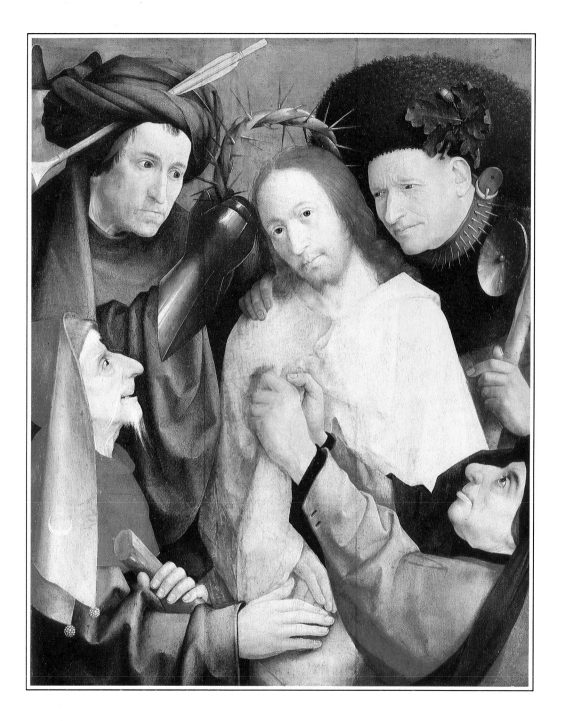

Detail

▷ **The Wayfarer**

Oil on panel

In the Late Middle Ages the course of a person's life on Earth was understood to be a pilgrimage from birth to death. The idea of the wayfarer was, therefore, of great significance to the Christian life. Depictions of this allegory were studied with great care for indications of dangers and pitfalls, of what and what not to do in this life. Bosch had treated the subject on the outside panels of *The Haywain*, and the same pose with different background messages is seen in this circular panel painted about 10 years later. Set in one of

Bosch's most delicate and sensitively observed Dutch landscapes, the tattered scarecrow figure is pausing as he passes a dilapidated tavern. Possibly he is wondering if the woman gazing from the broken shuttered window has the same interest in him as the two 'lovers' in the doorway have in each other. The sordid scene is emphasized by the peasant urinating on the corner of the inn. The painting is different from *The Haywain* panels in showing only the spiritual and sensual dangers that the wayfarer encounters.

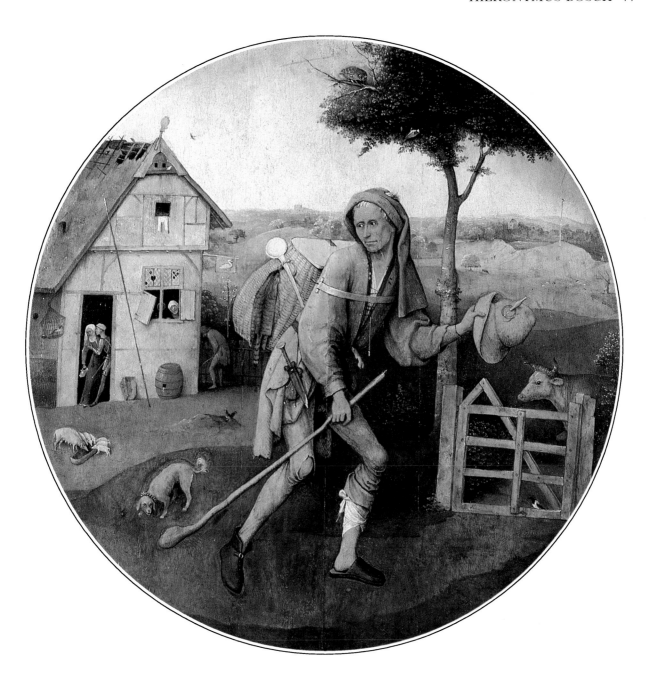

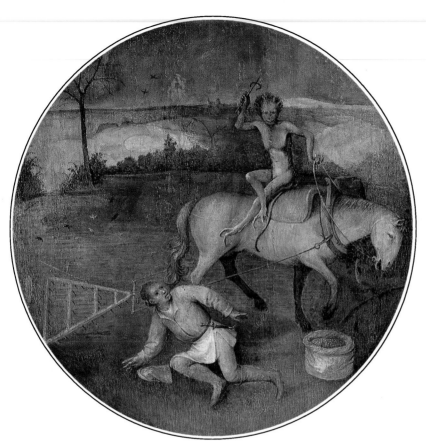

◁ **Ploughman Unhorsed by Devil** (*detail from* Mankind Beset by Devils)

Oil on panel

Two small panels that may have formed, or been intended to form, the wings of an altarpiece, each carry a full picture on one side: *The Fall of the Rebel Angels* and *Noah's Ark on Mount Araratt.* On the reverse side are four circular paintings showing scenes of people being beset by devils during the mundane pursuit of their ordinary working lives. In one, devils have driven a farmer from his farm; in another, they have attacked a traveller; and in the one illustrated here they have knocked a ploughman from his horse. (In the fourth painting the Christian soul finds asylum.) It epitomizes in many ways the medieval belief in the real unseen existence of devils and demons everywhere. For Bosch, who all evidence shows to have been a depressive, morbid character, it is the simplest message of an everpresent danger. Constant vigilance must accompany everyone everywhere; devils are really ready to pounce. The ploughman sees the devil – or did he just fall off his horse?

ACKNOWLEDGEMENTS

The Publisher would like to thank the following for their kind permission to reproduce the paintings in this book:

Bridgeman Art library, London/Prado, Madrid: 8-9; /**Musee d'Art et d'Histoire, St.Germain-en-Laye/Giraudon:** 10; /**Prado, Madrid:** 12-13, 14 & 15, 16 & 17; /**Museum Boymans-van Beuningen, Rotterdam:** 18; /**Prado, Madrid:** 19; /**Louvre, Paris/Giraudon:** 20; /**Kress Collection, Washington D.C.:** 21; /**Palazzo Ducale, Venice:** 22-23; /**Gemaldegalerie der Bildenden Kunste, Vienna:** 24, 25, 26 & 27; /**Akademie der Bildenden Kuste, Vienna:** 28 & 29; /**Akademie der Bildenden Kunste, Vienna;** 30 & 31; /**Gemaldegalerie der Bildenden Kunste, Vienna:** 32 & 33, 34 & 35, 36 & 37, 38 & 39, 40 & 41; /**Prado, Madrid:** 42 & 43, 44 & 45, 46 & 47, 48 & 49, 50 & 51, 52 & 53, 54-55, 56 & 57, 58, 59, 60, 61; /**Museo Lazaro Galdiano, Madrid:** 62; /**Museum voor Schone Kunsten, Ghent:** 63; /**Musée des Beaux-Arts, Valenciennes/Giraudon:** 64 & 65; /**Museu Nacional de Arte Antiga, Lisbon/Giraudon:** 66, 67, 1/2 title, cover; /**Museo de Arte, Sao Paulo/Giraudon:** 67; /**Museu Nacional de Arte Antiga, Lison:** 68; /**Prado, Madrid:** 69; /**Museum voor Schone Kunsten, Ghent:** 70, 71, 72 & 73, 74; /**National Gallery, London:** 75; /**Museum Boymans-van Beuningen, Rotterdam:** 76 & 77, 78

Every effort has been made to trace the copyright holders and we apologise in advance for any unintentional omissions. We would be pleased to insert the appropriate acknowledgement in any subsequent edition of this publication.